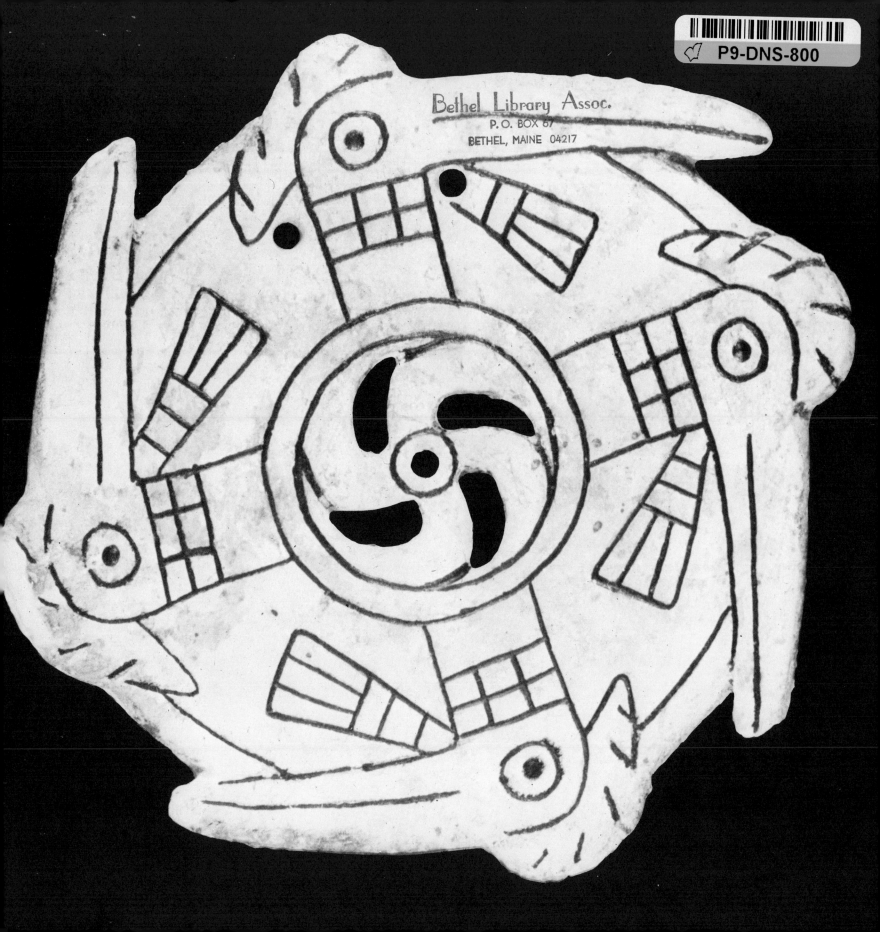

Endpapers: Shell gorget,
Stovall Museum of Science and History,
University of Oklahoma, Norman

Title page: Copper plaque,
Ohio Historical Society, Columbus

The Art of the Southeastern Indians

By Shirley Glubok

DESIGNED BY GERARD NOOK
SPECIAL PHOTOGRAPHY BY ALFRED TAMARIN

MACMILLAN PUBLISHING CO., INC.
New York
COLLIER MACMILLAN PUBLISHERS
London

The author gratefully acknowledges the assistance of:
Jeffrey Brain, Associate Curator, Peabody Museum, Harvard University; *Joffre L. Coe,* Director of Research Laboratories of Anthropology, University of North Carolina; *Hester Davis,* State Archaeologist of Arkansas; *Caroline Dosker,* Registrar, The University Museum, University of Pennsylvania; *Alfred K. Guthe,* Director, The Frank H. McClung Museum, University of Tennessee; *Mark R. Haggitt,* Educational Coordinator, C. H. Nash Memorial Museum, Memphis State University; *B. Calvin Jones,* Archaeologist, State of Florida; *Sally Schaefer Klass,* Museum Technician, National Museum of Natural History, Smithsonian Institution; *Claudia N. Medoff,* Keeper of Collections, American Section, The University Museum, University of Pennsylvania; *Joan Morris,* Curator, State Photographic Archives of Florida; *Jerald T. Milanich,* Assistant Curator in Archaeology, The Florida State Museum, Gainesville; *David J. Wanger; Leo Jakobson;*
and especially the helpful assistance of *Vincent Wilcox,*
Curator of North American Archaeology and Ethnology, Museum of the American Indian.

Macmillan Publishing Co., Inc., 866 Third Avenue, New York, N.Y. 10022
Collier Macmillan Canada, Ltd.
Printed in the United States of America

10 9 8 7 6 5 4 3 2 1

Library of Congress Cataloging in Publication Data
Glubok, Shirley. The art of the southeastern Indians.
SUMMARY: A survey of the art and history of the various Southeastern Indian tribes from 5000 B.C. to the present. 1. Indians of North America—Southern States—Juvenile literature. 2. Indians of North America—Southern States—Art—Juvenile literature. [1. Indians of North America—Southern States. 2. Indians of North America—Southern States—Art] I. Title.
E78.S65G58 709′.01′1 77-20850 ISBN 0-02-736480-1

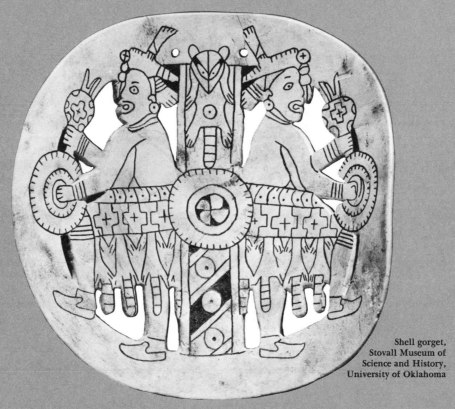

Shell gorget,
Stovall Museum of
Science and History,
University of Oklahoma

For hundreds of years before Europeans arrived in the New World, the southeastern part of what is now the United States was inhabited by native people who had a highly developed culture. They belonged to various groups, which were different in many ways but alike in others. They lived in towns that had great ceremonial centers, and grew food in garden plots that surrounded their villages. Also they hunted and fished and gathered wild nuts, fruits and berries.

The Southeastern Indian culture extended westward from the Atlantic Ocean to what is now eastern Oklahoma, and northward from the Gulf of Mexico to the southern Appalachian Mountains. Works of art created by these people have been found buried in the earth with the dead. They were probably connected with religious ceremonies.

The Indians who lived in North America before Europeans brought them iron tools and weapons are considered Stone Age people. They made their weapons and tools from stone; they did not use metal, except for a little copper. In earliest times they hunted with stone points attached to short wooden spears. An atlatl, or throwing stick, was used to increase the force of the hunter's throw. In later times the bow and arrow was used.

Below, left, is a stone point from Tennessee which is probably seven thousand years old. Points were made of hard stone, usually flint. They were formed by chipping, or striking the piece of stone with another stone, or by pressing on it with a small piece of stone or antler in order to detach flakes.

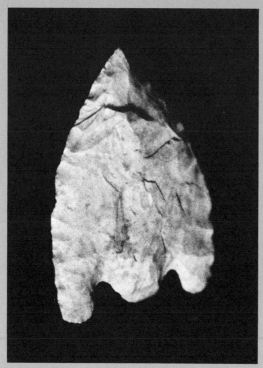

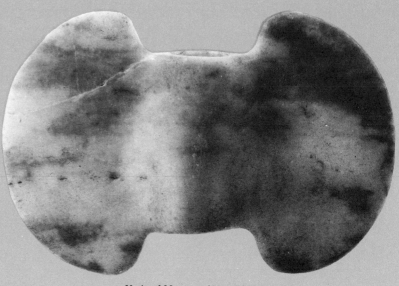

National Museum of Natural History,
Smithsonian Institution

Frank H. McClung Museum, University of Tennessee,
Knoxville, photograph by Alfred Tamarin

An object called a bannerstone might sometimes have been attached to the atlatl shaft, perhaps to help balance it. The bannerstone below, near left, is from Louisiana. After a kill, stone knives were used to cut up the animal.

North American Indians were skillful at making weapons and tools from materials that were available around them. In Florida, where conch shells were plentiful, they were attached to wooden handles with rawhide thongs and used as clubs.

The shark's tooth at right is from South Carolina. On the Atlantic Coast, sharks' teeth that had become fossilized, or stone-hard with age, were attached to antlers or to wooden handles and used as knives. Sharks' teeth and shells were often traded to Indians who lived far from the coast.

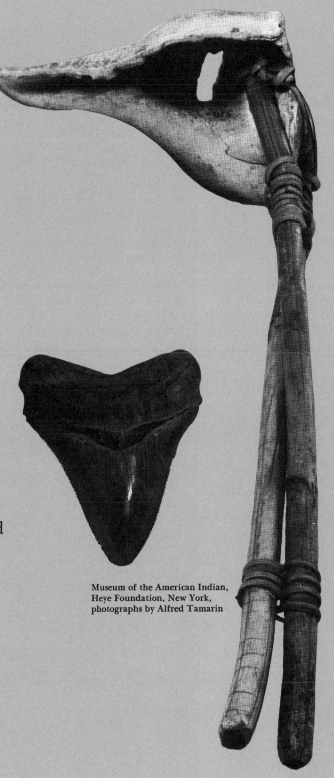

Museum of the American Indian,
Heye Foundation, New York,
photographs by Alfred Tamarin

5

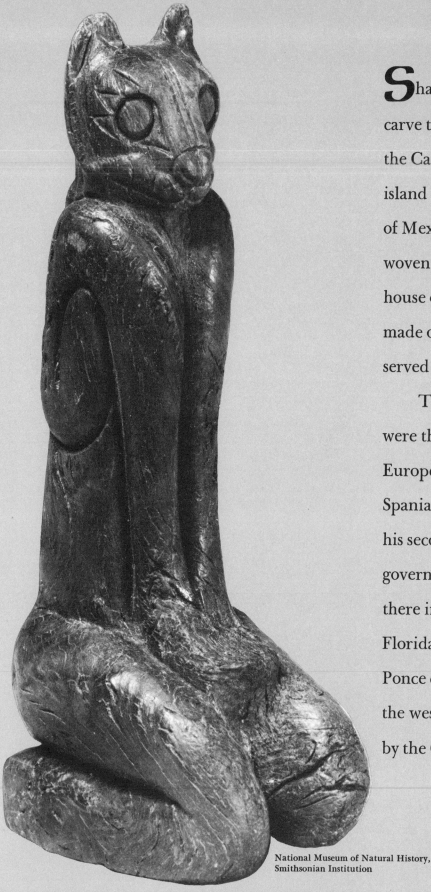

Shark's tooth knives were probably used to carve these wooden figures. They were made by the Calusa or their ancestors on Key Marco, an island off the west coast of Florida in the Gulf of Mexico. These people lived in huts made of woven mats, built on piles of oyster shells. The house of the chief stood near the shore on a hill made of shells, and a huge mound of shells served as a platform for a temple.

The Calusa, who were valiant warriors, were the first Southeastern Indians to meet the European explorers. Juan Ponce de León, a Spaniard who had accompanied Columbus on his second voyage to America and then become governor of Puerto Rico, sailed northeast from there in 1513. He landed on a coast he named Florida, and claimed the land for Spain. In 1521 Ponce de León returned to establish a colony on the west coast of Florida, but he was driven away by the Calusa and died from an arrow wound.

National Museum of Natural History, Smithsonian Institution

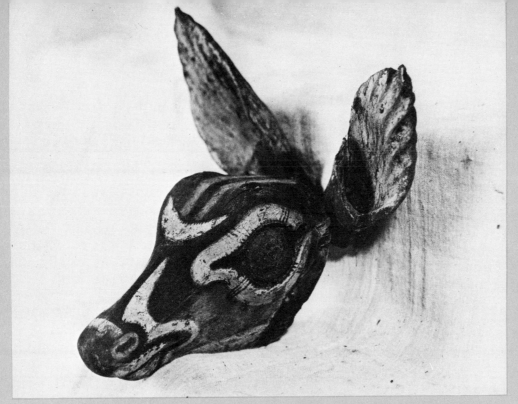

These carvings are among the finest wood sculptures in North America. The figure of a kneeling man wearing a panther-skin disguise is less than six inches high. The deer head, above, and the sea turtle, below, have designs painted on them. The deer head probably had carved antlers and tortoise-shell eyes, but they have been lost. The ears were carved separately and attached with leather hinges so they could be moved with strings.

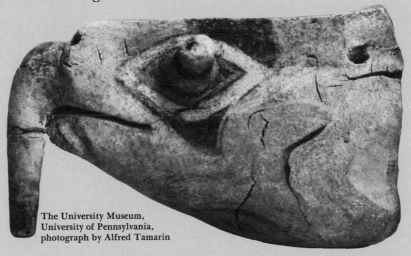

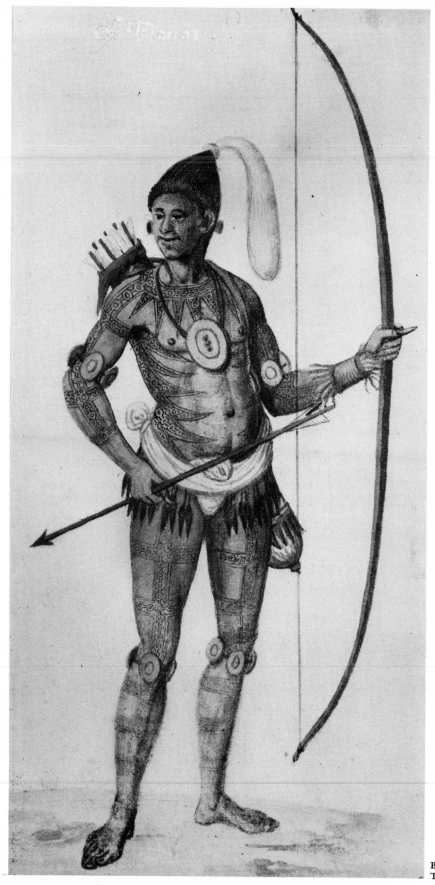

The Timucua were living in northern Florida and southern Georgia when the early European explorers arrived. The Timucua were tall, strong and athletic. The women were excellent swimmers who could cross a river with children on their backs, and the men were fine hunters and warriors. They fought off Hernando de Soto, a Spanish governor of Cuba who set out in 1538 to conquer Florida for King Charles V of Spain. For weapons the Timucua used bows carved of wood from the yew tree and strung with buckskin. Arrowheads were made of flint or fish bone.

Timucuan men wore deerskin breechcloths. A breechcloth is a wide strip of skin or cloth that fits between the legs. A belt holds the cloth in place, and the ends hang over in both front and back. Women's skirts were woven of Spanish moss, a plant that grows on trunks and branches of trees in the

By John White, about 1587,
The British Museum

South. Sometimes the skirt was tied over the shoulder, leaving one breast bare. Cloaks for men and women were made of feathers or of fabric woven from the inner bark of the mulberry tree.

These drawings of a Timucuan chief and his wife were made by a European traveler. The chief wears copper jewelry. His wife is wearing shell beads, and ear spools, which were inserted through slits in the ear lobes.

The man's hair is tied in a point on top of his head, with an animal tail dangling from it. Both have painted designs on their faces and tattooing over most of their bodies. Tattooed designs were made by pricking the flesh with a sharp instrument dipped in colors that came from minerals and plant dyes. The chief and his wife have long, sharp fingernails, which were considered beautiful and could also be used as weapons.

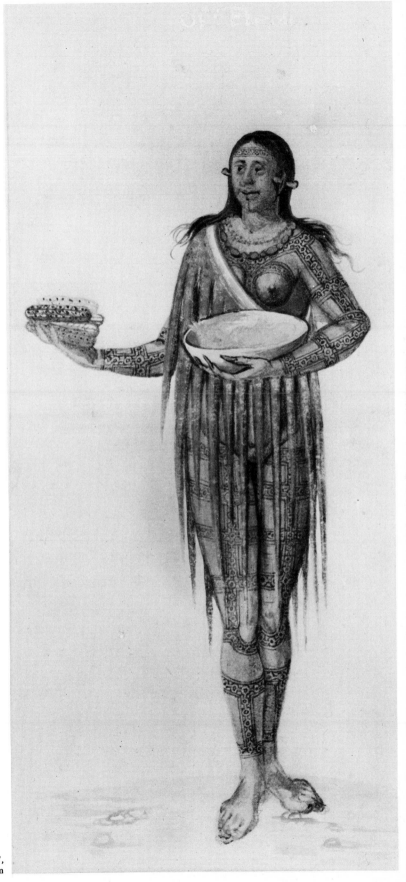

By John White, about 1587,
The British Museum

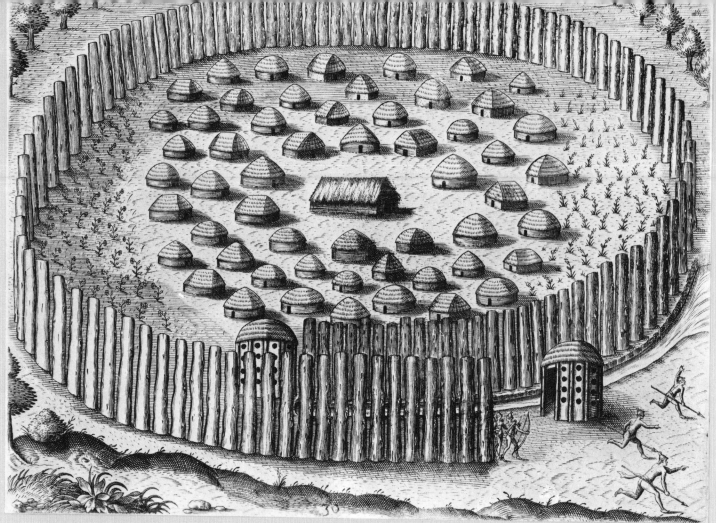

From a painting by Jacques Le Moyne de Morgues, 1564, in *Narrative of Le Moyne* (1875), Library of the Museum of the American Indian, photograph by Alfred Tamarin

This drawing of a Timucuan village was made by a Frenchman who visited Florida in the late sixteenth century. A fence of upright logs surrounds the village for protection. At the entrance are two guard houses. In the middle is the chief's dwelling and around it are homes of important people. The houses, which were round, had frameworks of wooden posts, with roofs made of palm branches. There was a door in each house, but no windows. An opening in the roof allowed the smoke of the cooking fire to escape. In winter people slept on beds of timber, covered with bear skins. In summer they slept out of doors on the ground.

The Timucua lived by hunting and fishing and by collecting shellfish on the shore and nuts, roots and berries in the forest. They planted some corn, beans, squash and tobacco. After the Spanish founded St. Augustine, Florida, in 1565, the Timucua were conquered and converted to Christianity. They lived in or near the Spanish missions, which were often raided by British from South Carolina, who captured Indians as slaves. By 1720 the Timucua as well as the Calusa had been largely destroyed by warfare, slave raids and diseases brought by Europeans.

The Acolapissa were a group of Choctaw Indians who lived on the Pearl River, north of what is now New Orleans, Louisiana. A French artist who was in Louisiana in the early eighteenth century made the drawing below of an Acolapissa temple. The walls and roof are made of mats woven from cane, a plant that grows in the marshes around rivers and streams.

By A. de Batz, 1732, Peabody Museum,
Harvard University, Cambridge, Massachusetts

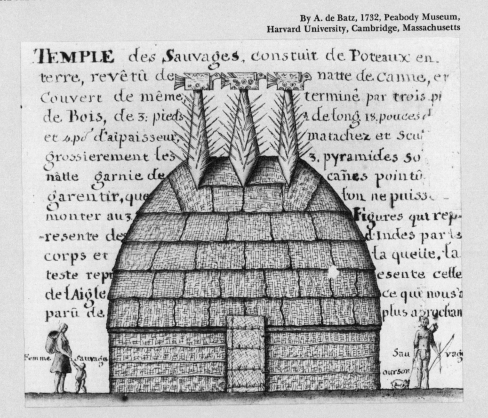

Indians of the Southeast had ceremonial centers where great mounds of earth served as platforms for temples and houses. The Temple Mound Period, when these flat-topped earthworks were built, began around 1,300 years ago. For more than a thousand years before that, the Indians had built mounds, but they were chiefly for burial. The Temple Mound Period lasted until after the Europeans arrived.

The stone bowl below is from an ancient ceremonial center known as Moundville, in northern Alabama. There are more than twenty flat-topped earth mounds in the area, which were foundations for the dwellings of chiefs and priests. The dirt was carried to the mounds a basketful at a time. Surrounding the mounds was a village area with a fence around it. People were buried in cemeteries at the base of some of the mounds and also in the mounds themselves.

Museum of the American Indian,
Heye Foundation

12

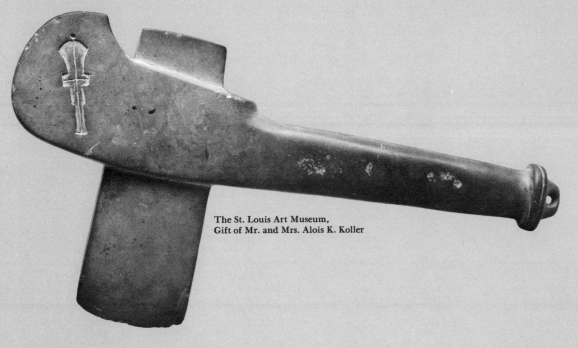

The St. Louis Art Museum,
Gift of Mr. and Mrs. Alois K. Koller

Ancestors of the Creeks in Georgia made the polished stone ax above during the Temple Mound Period. A single block of gray slate was used. The ax was made for ceremonies, but it is a copy of axes with stone or copper blades that were used every day. The design of a ceremonial mace, or war club, is incised, or cut, into the stone.

Near the Duck River in Tennessee there is a quarry where enormous boulders of flint could be found. Indians in the area broke up the boulders to get thin slabs of flint to make the ceremonial objects at right. These were carefully buried in graves and are thought to be symbols of the high rank of the owner.

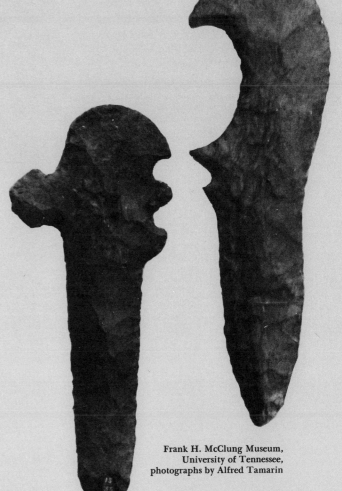

Frank H. McClung Museum,
University of Tennessee,
photographs by Alfred Tamarin

13

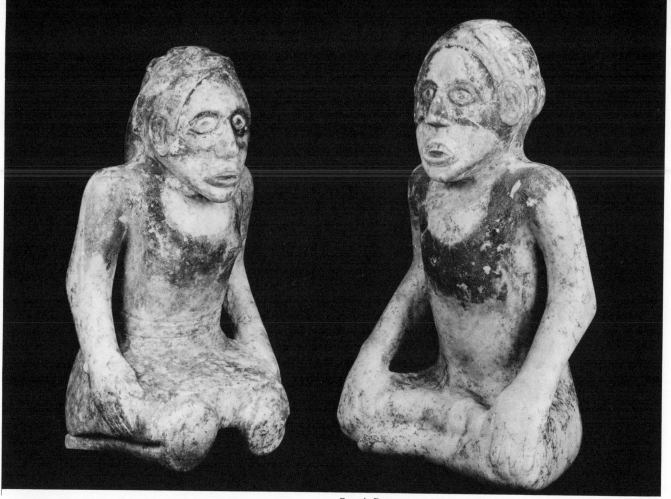

The painted marble figures of a woman and a man, above, might represent ancestor portraits, or idols. They were buried in a tomb lined with stones in a pit at the base of a mound at Etowah, Georgia. There are at least seven mounds in the village, on top of which temples and the homes of chiefs and priests once stood. The mounds are grouped around two public squares. The largest mound is fifty-three feet high. A ramp made of clay, with log steps, leads to the top.

The sandstone figure at right, which is a foot and a half high, has the wrinkled face of an old man. Traces of paint still remain on him, even though he was buried for centuries in Tennessee. A female figure was found with him.

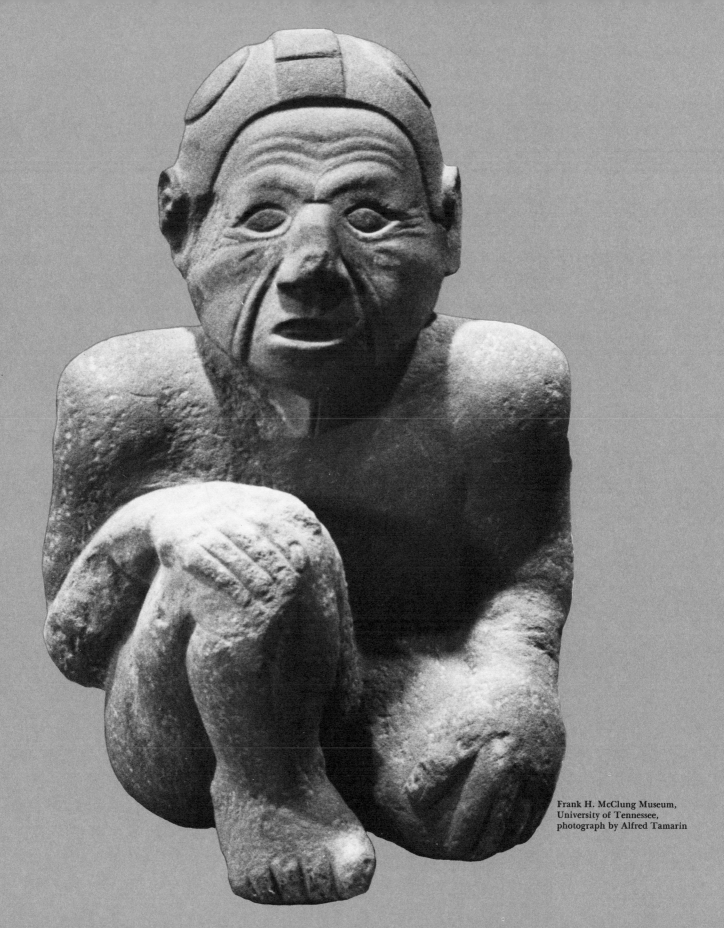

Frank H. McClung Museum,
University of Tennessee,
photograph by Alfred Tamarin

15

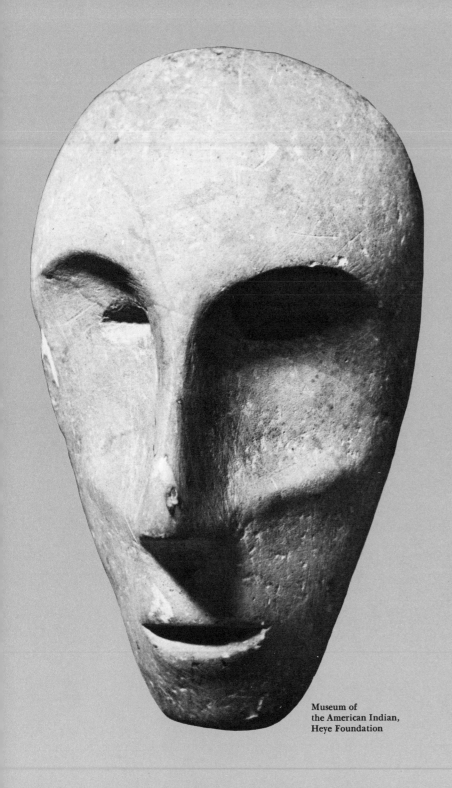

Museum of
the American Indian,
Heye Foundation

The stone head at left, from a temple mound in Kentucky, may have been a mask on a wooden statue used for ceremonial purposes. Southeastern Indians were skilled workers with wood, but few of these carvings remain because wood does not last. The head, which is nearly ten inches high, is partly hollowed out in back, but there are no eye holes.

A polished stone object was made by first pecking, or chipping, a piece of stone into rough form. A hole was made by placing sand on a spot and rotating a solid stick or hollow cane on the sand. Then the object was ground into final shape and polished with a natural abrasive such as sandstone.

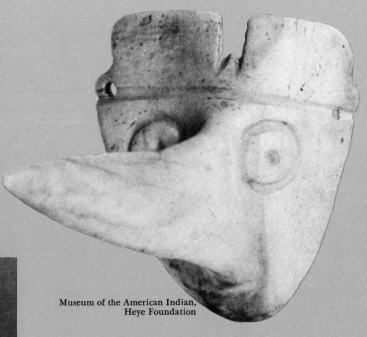

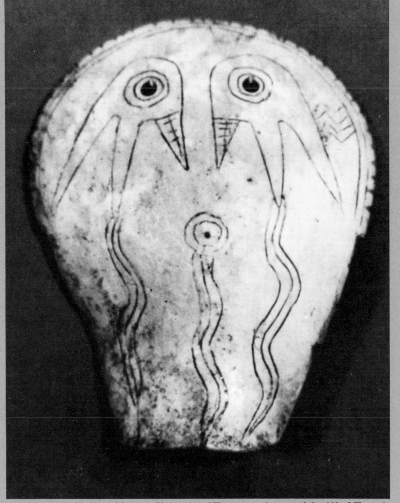

The small mask above was carved out of the thick side of a conch shell. Small masks with long noses, made of copper, bone or shell, were common in the Temple Mound Period. These long-nosed masks were perhaps connected with religious ceremonies held on the temple mounds.

Masks cut from large ocean shells often have a pattern of lines coming from the eyes, called the "forked eye" design. The masks were found in burials, on the chests or faces of skeletons, especially in Tennessee.

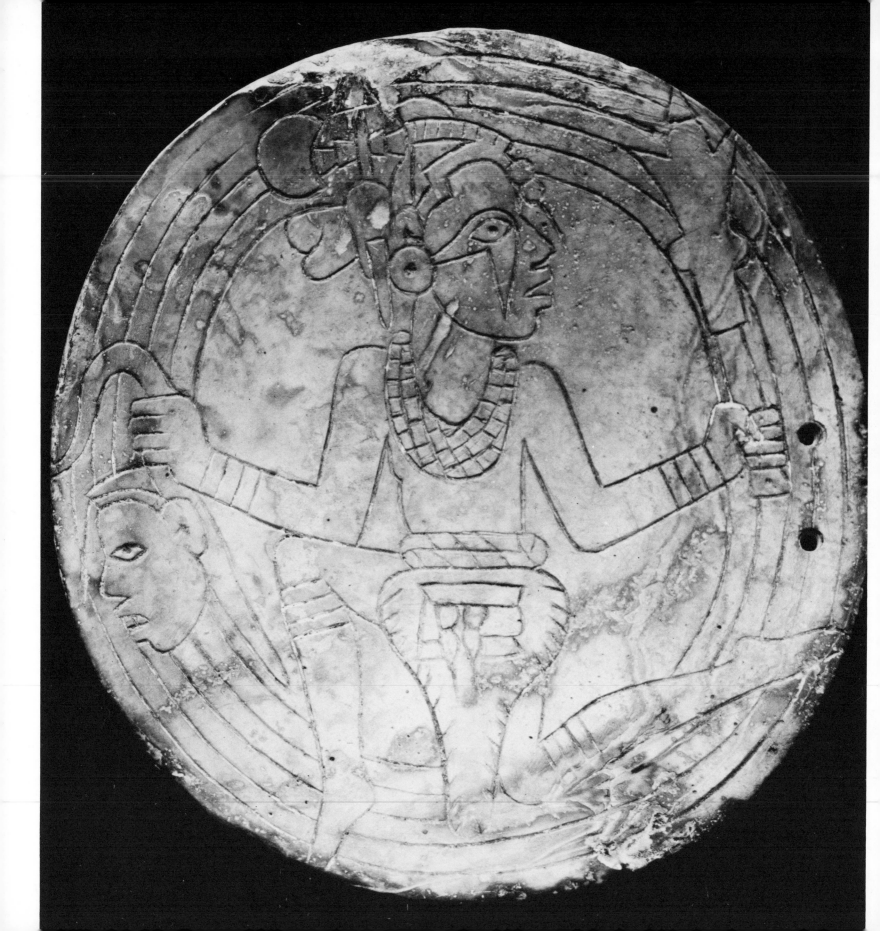

Trophy heads probably played a part in ceremonies among the Southeastern Indians. At left is a figure of a warrior holding the head of a victim as a trophy, incised on a shell gorget from Tennessee. Gorgets were worn around the neck by important people and often have been found on the chests of skeletons.

They were cut from conch shells and engraved with stone tools. Black paint made from burned plants or trees was rubbed into the lines to make them stand out. The warrior's face on the gorget at left has the forked eye design. He is wearing an elaborate headdress and carrying a mace.

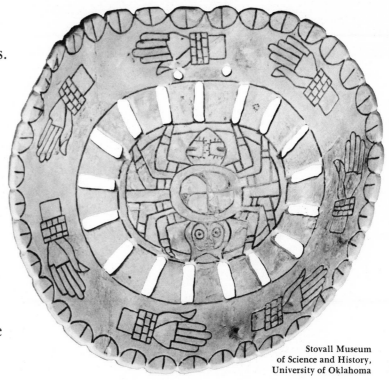

Stovall Museum
of Science and History,
University of Oklahoma

The shell gorget above, from Spiro Mound in eastern Oklahoma, was cut out with an openwork design. A spider is in the center, surrounded by a sun disc. According to Cherokee legend, Water Spider brought fire to the world. In the beginning the world was cold; there was no fire. Then Thunder sent Lightning to put fire into a hollow tree which grew on an island. No one could reach it because of the water. Finally Water Spider spun a thread from her body and wove it into a bowl which she fastened onto her back. She crossed over to the island, put a coal of fire into her bowl and took it back to the people.

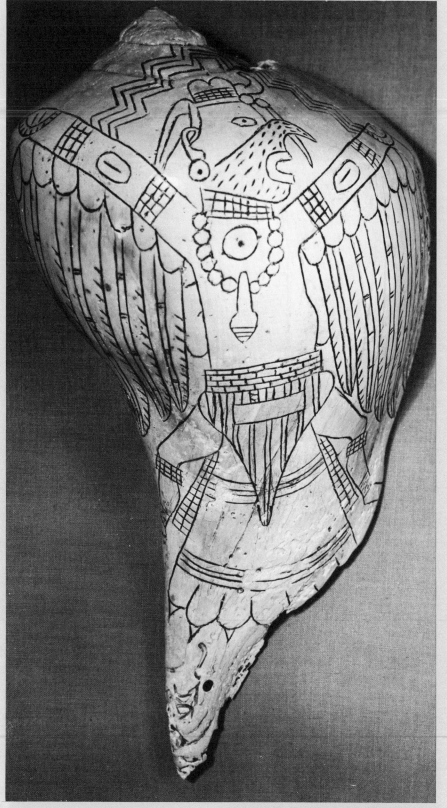

Ceremonial vessels used as drinking cups and dippers also were made from conch shells. A figure of a dancing warrior is engraved on a conch shell cup at left, from Spiro Mound. The man wears an eagle costume and eagle mask. This bird was considered sacred and its feathers were valued above those of all other birds. An eagle could be killed only by a professional eagle killer, who knew prayers to prevent the bird from taking revenge on his village.

Conch cups were used to serve the "Black Drink," a bitter beverage made from tobacco and holly leaves. This liquid was taken in great quantities to cause vomiting and cleanse a person of evil. It was thought to have medicinal qualities also. The Black Drink ceremony was held before all important meetings of the council and before a battle.

A man is paddling a canoe in the engraving on the fragment of a conch shell at right. Southeastern Indians made dugout canoes from the long, thick trunks of poplar or cypress trees. A tree was felled by making a fire on the ground around it. The branches were burned off and the bark scraped away with shell tools. The trunk was hollowed out by burning it, bit by bit, and scraping away the ashes with shell or stone tools. Indians in Florida still make and use dugout canoes today.

National Museum
of Natural History,
Smithsonian Institution

Conch shells were also used for trumpets. The spire, or tip, at the broad end of the shell was ground off to make a hole for blowing. Trumpet players often accompanied the chief to announce his presence.

The spiral center of the conch was used for making tools and beads which were worn on necklaces and in ear lobes. The headdresses worn by the dancing warrior and the man in the canoe have conch-shell beads that hang over their faces.

Research Laboratories of Anthropology,
University of North Carolina, Chapel Hill,
photograph by Alfred Tamarin

A ring of conch-shell beads was found in the pottery vessel at left. The beads had been laid over the little body of a child who had died around five hundred years ago and was buried in the pot. The vessel was placed in a grave in Town Creek, a ceremonial center in North Carolina, but first it was ceremonially "killed," or broken. A hole was punched in the bottom of the pot to release its spirit.

The vessel, which is about two feet high, was made by modeling clay into shape and patting the walls, or sides, with a paddle to smooth them while the clay was still damp. The paddle was wood, wrapped with coarsely woven fabric, which left a design. Sometimes designs were made by cutting patterns into the wood or wrapping the paddle with cord.

When a person died, pots were placed in his or her grave for use in the afterlife. The bowl at right, from Tennessee, has swirling designs that were incised in the soft clay with a sharp twig. Before the pot was modeled, crushed shell was mixed with the clay. The designs near the neck of the pot were made by adding extra clay and punching holes into it.

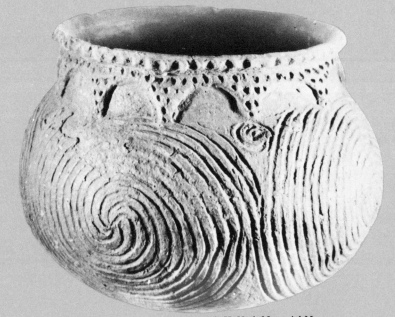

C. H. Nash Memorial Museum,
Memphis State University

In later times vessels made just for burial were sometimes "pre-killed." Holes to release the spirit were made before the pot was fired, or baked.

This vessel was made for an offering in a burial mound in Florida. The openings in the walls form a cut-out design. Bird heads decorate the rim.

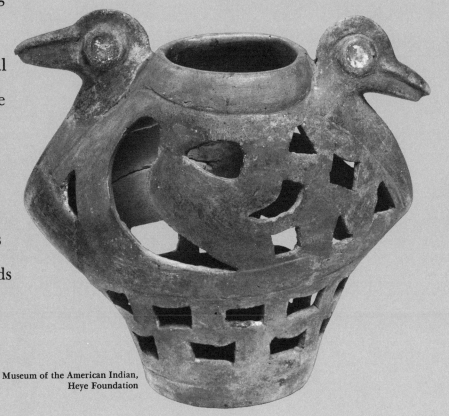

Museum of the American Indian,
Heye Foundation

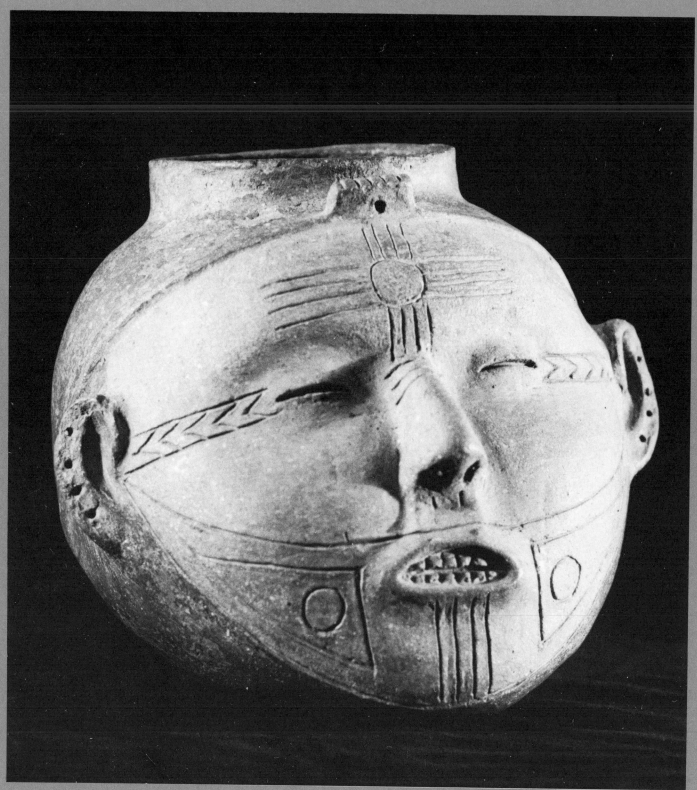

24

Pottery jars were sometimes formed to represent trophy heads, with eyes closed and lips slightly parted. The jar at left, from Arkansas, has a circle and cross incised into the forehead. The circle and cross perhaps represent the center of This World and the four directions. The other lines probably represent facial tattooing. Several holes were cut into the ears, for earrings.

The pottery dog with a curly tail, below, is from a stone grave in Tennessee. The decoration is called negative design: the circles and lines were applied in wax, then the rest of the surface was painted. When the vessel was fired, the wax melted, leaving the design in the color of the natural clay.

The dog was the only domestic animal raised by Southeastern Indians in prehistoric times. The period before European settlement in North America is called prehistoric because the Indians did not have a written history. The period after European settlement is called historic.

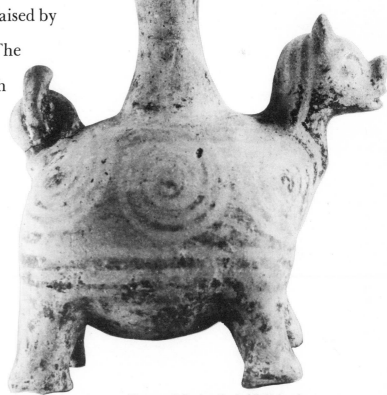

Thruston Collection, Vanderbilt University,
Nashville, Tennessee, photograph by Peggy Wrenne

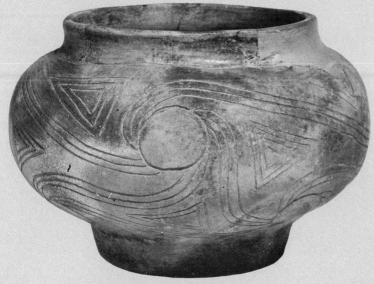

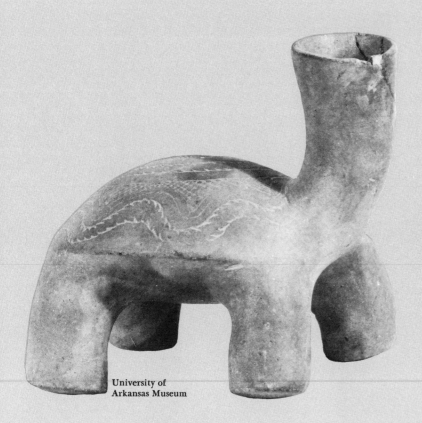

A Natchez Indian of Louisiana made the pot at left in historic times. The Natchez were the largest and most powerful tribe in the lower Mississippi Valley. They were sun worshipers, ruled by a monarch known as The Great Sun. No one was allowed to speak to him except from a distance. The common people were known as Stinkards. When The Great Sun died, his wife and servants were killed so they could be with him in the afterlife. The Natchez were driven out of their villages by Frenchmen who settled in the lower Mississippi Valley in the early eighteenth century. They were captured by the French and sold as slaves; those who escaped went to live with other tribes.

A thousand years ago the Caddo were settled farmers in what is now Arkansas and

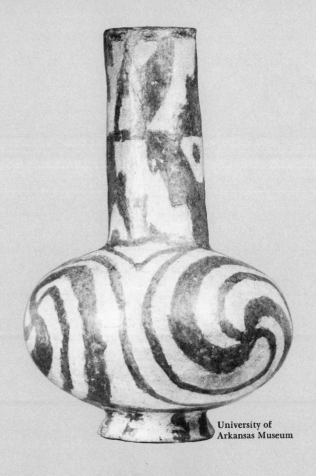

University of
Arkansas Museum

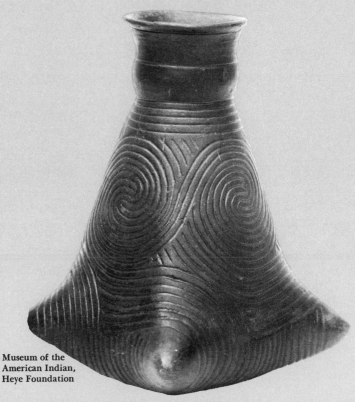

Museum of the
American Indian,
Heye Foundation

Louisiana. They lived in domed houses shaped like beehives, with mud walls and thatched roofs. The Caddo made pots in a variety of forms. The headless turtle has an incised design on its back to represent its shell.

The Caddoan water bottle at left was carefully modeled and painted with a double scroll design, two circles connected by a line. Paint made from red ocher, earth that contains iron ore, was applied to the natural clay to create the pattern.

The black pot, also Caddoan, has a square base and an overall scroll design incised into the surface. The vessel was blackened by smudge firing. While the pot was being fired, the oxygen supply was cut off by smothering the fire. The lack of oxygen made the vessel turn black.

Pipe smoking was an ancient ceremonial custom among the Southeastern Indians. Fire was connected with the sun, and smoke was associated with clouds. Carved pipes had long stems of cane or reed, often decorated with eagle feathers. Substances such as dried sumac leaves were added to tobacco for smoking. Tobacco pouches made of animal skin were kept in a sacred place.

During council meetings a pipe was lit and the chief blew puffs of smoke toward the Great Spirit above the earth, then toward the four directions. The pipe was passed to all present, in order of rank. When a traveler arrived in a village, he was immediately offered tobacco, as well as food, as a sign of welcome.

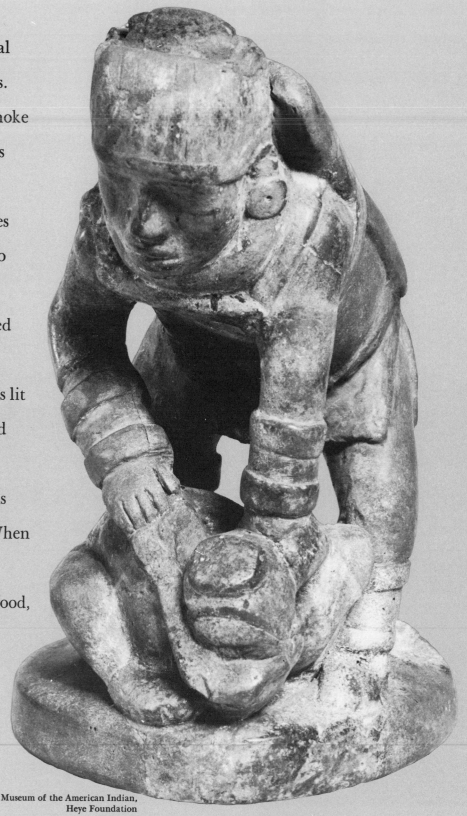

Museum of the American Indian,
Heye Foundation

28

During the Temple Mound Period, ceremonial pipes were buried with people. The pipes were elaborately carved from hard stone in the form of birds, animals or men on a flat base. A bowl-shaped opening in the back of the figure held the tobacco. A hole drilled through the base led to the bottom of the bowl, and a hollow stem was inserted in the hole to puff smoke. Some pipes were as tall as ten inches and some weighed as much as eighteen pounds.

The standing warrior bending over to kill his victim, from Spiro Mound, is about ten inches tall. He wears a turbanlike headdress and a protective breastplate that covers his chest and back. The pipe below is carefully carved so that the details of the flat headdress and the wrist- and armbands can be seen clearly.

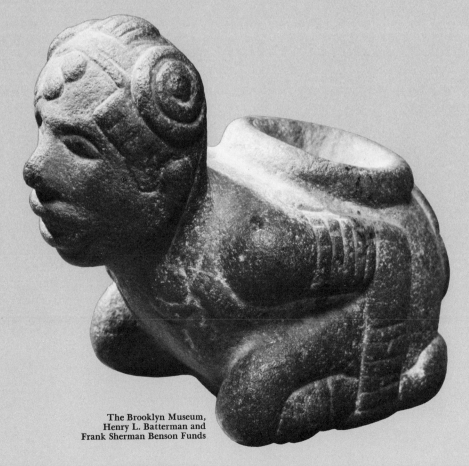

The Brooklyn Museum,
Henry L. Batterman and
Frank Sherman Benson Funds

29

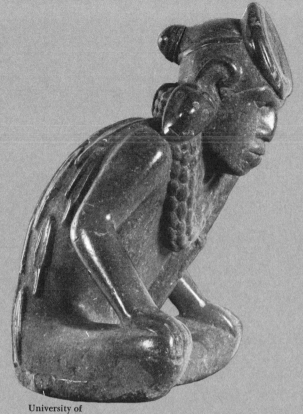

University of
Arkansas Museum

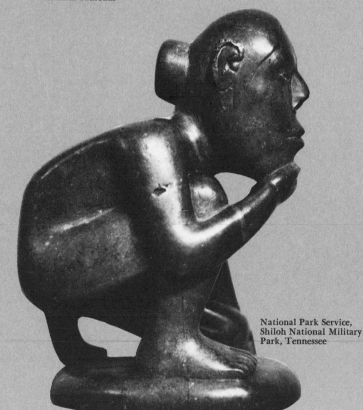

National Park Service,
Shiloh National Military
Park, Tennessee

The polished stone pipe at left, from Spiro Mound, is in the form of a seated man. He is wearing a fur or feathered cloak on his back and a flat cap. His hair is combed into a knot at the back of his head. Four strands of beads hang from his neck; his large ear ornaments are in the form of masks. The pipe at left, below, in the form of a man crouching, is from Tennessee.

The circular pipe, from Kentucky, represents a lizard. It is less than three inches high. To make a pipe, the prehistoric sculptor chose stone that could withstand heat. He carved it into rough shape, then bored out the bowl and made a hole for the stem. Then he shaped it and polished it by rubbing it with

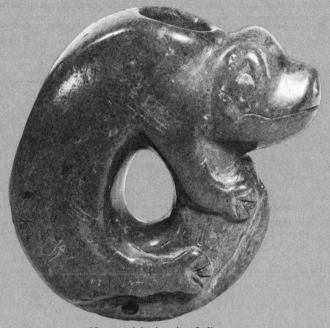

Museum of the American Indian,
Heye Foundation

another stone or with sand and water.

In the nineteenth and early twentieth centuries, the Cherokee of North Carolina made pipes of slate, which is soft and easily carved. Metal tools had become available through trade; blocks of slate were roughly cut into shape with a saw and carved into final form with a metal knife. Then the pipes were rubbed with grease to make them look shiny and dark. When tobacco was smoked in a pipe, the heat turned the slate hard.

A figure of a seated man decorates a Cherokee pipe. The stems of Cherokee pipes were willow, from which the pith, or soft core at the center, had been forced out. Ornaments of feathers and bells were hung from the stems.

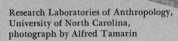

Research Laboratories of Anthropology,
University of North Carolina,
photograph by Alfred Tamarin

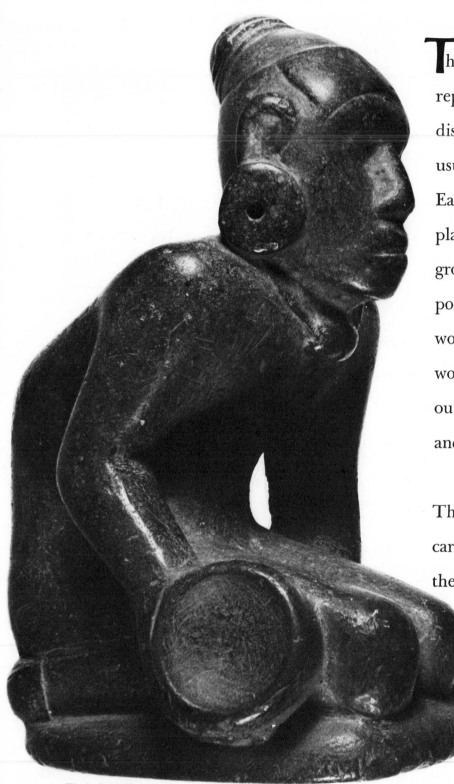

This prehistoric stone pipe from Oklahoma represents a warrior holding a round, smooth disc called a chunky stone. Chunky was a game usually played by two men from the same tribe. Each had a pole about eight feet long. One player would roll the chunky stone across the ground; both would race after it and hurl their poles to the point where they thought the stone would stop. The one who came the closest would win. Onlookers would bet on the outcome of the game, even staking their jewelry and clothing.

At right is a chunky stone from Tennessee. These objects belonged to the tribe and were carefully preserved from one generation to the next.

The "ball game" was also played by Southeastern Indians. Two different tribes would oppose each other. Any number of players could participate so long as the sides

were even. Each player had two sticks, which were made of hickory or pecan wood. The wood was bent into a loop at one end and laced with strips of animal skin or vegetable fiber. The balls were deerskin stuffed with animal hair.

The game was played on a field with goals made of two posts at each end. The object was to pick up the ball with the sticks and throw it between the posts or strike one of the posts with the ball. The first team to score twelve points won the game.

The night before a ball game a dance was held, which lasted until dawn. Songs were sung, calling on spiritual beings to strengthen the players for the contest. The players fasted, and a priest performed ceremonies to bring victory.

A modern version of this game is called lacrosse. The lacrosse sticks at right are Cherokee and the ball is Choctaw. Cherokee players sometimes tied feathers to their sticks.

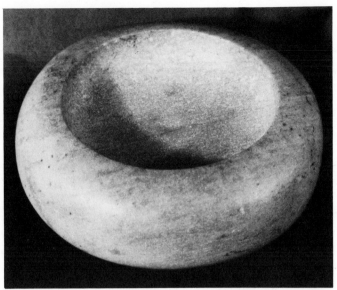

Frank H. McClung Museum, University of Tennessee,
photograph by Alfred Tamarin

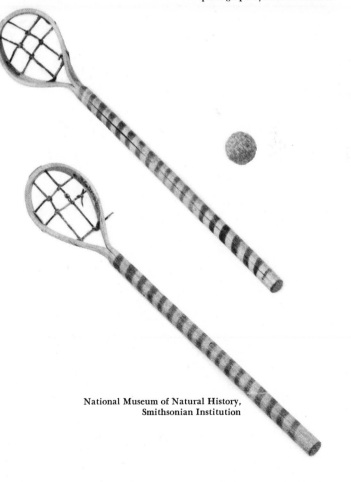

National Museum of Natural History,
Smithsonian Institution

33

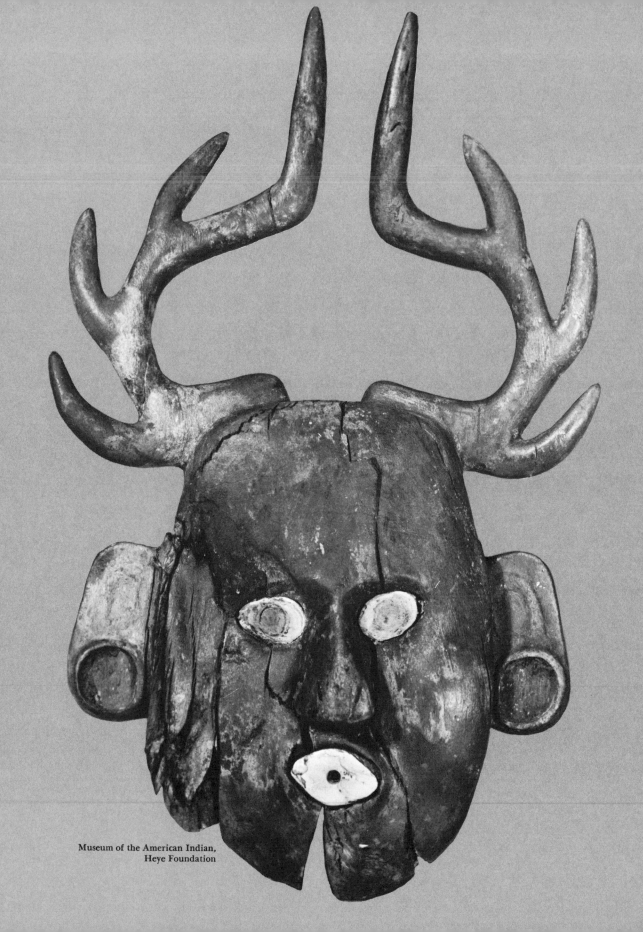

Museum of the American Indian,
Heye Foundation

Masks were worn by Southeastern Indians for ceremonial dances and as hunting decoys. A prehistoric shaman, or medicine man, at Spiro may have worn the wooden mask at left for a ceremony performed to promote good hunting. The mask has a human face and deer antlers. It was carved from a single block of cedar wood and painted. The eyes, mouth and ears were inlaid with shell.

The Cherokee mask at right, representing a wildcat, was made in the twentieth century. It was cut out of animal fur, with holes for the eyes, nose and mouth. The ears were added separately. A light and dark pattern on the mask was formed by trimming the fur in places to reveal the undercoat.

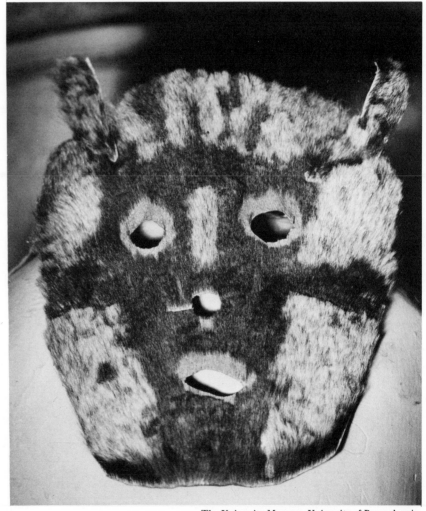

The University Museum, University of Pennsylvania,
photograph by Alfred Tamarin

The Cherokee use masks in their booger dance, which tells the story of the coming of the Europeans and the defeat of the Cherokee people. During the booger dance, men wear blankets wrapped around their bodies, and masks representing foreigners and Indians from other tribes. The dancers run after women and girls, frightening them so that they run away.

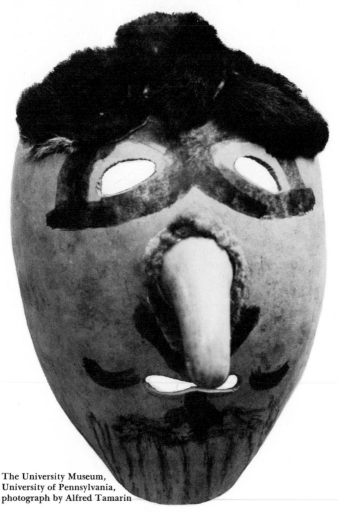

This booger mask is made from a gourd, a fruit with a hard rind that grows on a vine. The stem of the gourd forms the nose, which is encircled by a ring of fur. Painted lines rim the mouth and form the mustache and beard. The brows and hair are black fur.

At right is a Cherokee war dance mask made of wood. A warrior would show that he intended to fight by dancing with this mask. It has a coiled snake on top of the head. Snakes were considered to be special. Their teeth, shells, rattles and flesh were used for medicine. Hair is represented by paint on this mask. Stains from berries, black-walnut bark and earths were used to paint Cherokee masks.

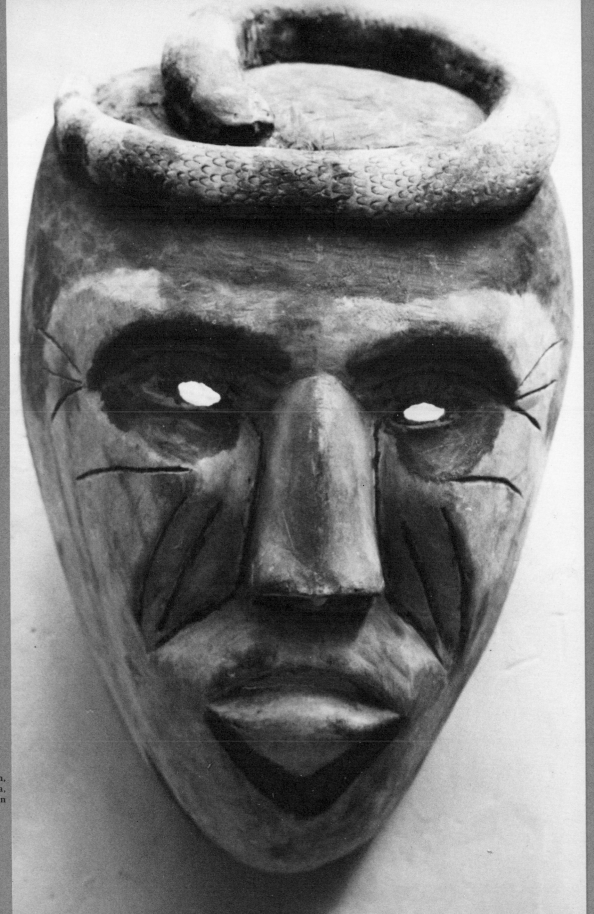

The University Museum,
University of Pennsylvania,
photograph by Alfred Tamarin

37

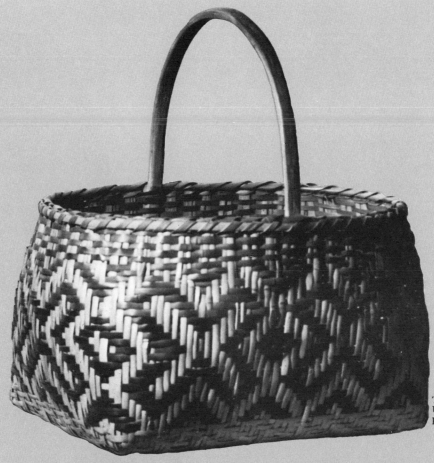

The University Museum,
University of Pennsylvania,
photograph by Alfred Tamarin

The Cherokee make baskets out of splints, or thin strips, of oak. The natural colors of the splints are different shades of tan and brown. When woven together they form a light and dark design. The Cherokee basket above has a wooden handle. Baskets were useful for carrying and storing fruit and corn and for storing important articles.

Cane, which grows along the banks of streams and rivers, has been used for weaving baskets and mats for centuries. After the cane is cut, the leaves are removed and the cane is split lengthwise. The tough outer skin is peeled off and soaked in pots of water. These narrow strips of cane can be colored with dyes and woven into bold designs. The dyes are made from plants such as black walnut, butternut and blood root.

The triangular vessel with two openings, called an elbow basket, is Choctaw. The craft of basket weaving is taught on the Choctaw reservation in Mississippi today. All of the Choctaw lived in Mississippi until they signed a treaty with the United States government in 1831 to move West to Oklahoma and Texas. Only a few stayed behind in their homeland.

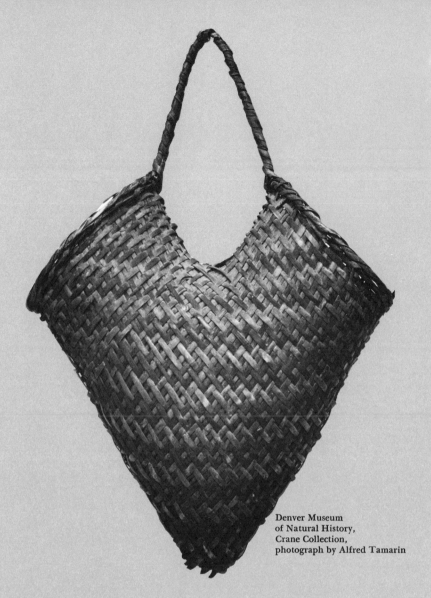

Denver Museum
of Natural History,
Crane Collection,
photograph by Alfred Tamarin

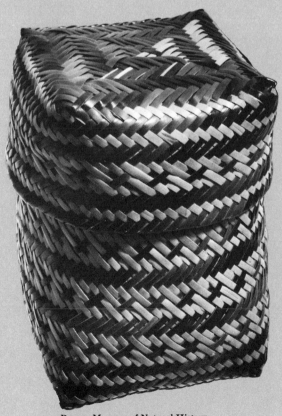

Denver Museum of Natural History,
Crane Collection, photograph by Alfred Tamarin

The basketwork container at left, by a Chitimacha weaver, has a lid that fits snugly. It is a "double weave" basket, one basket woven inside another in one continuous piece. In double weave, the design on the outside is different from the design on the inside.

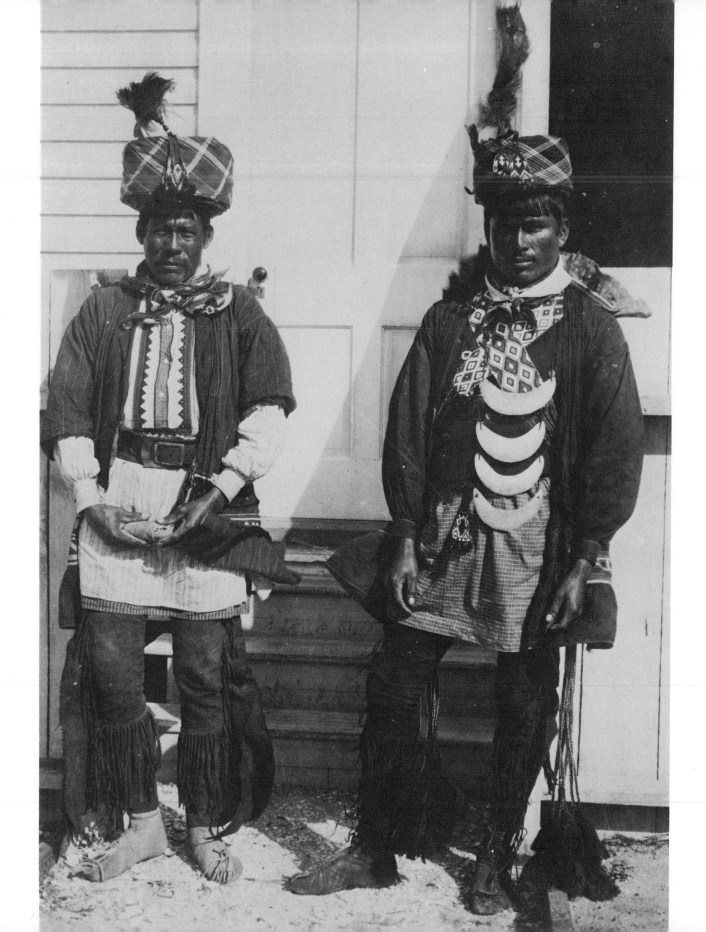

In the eighteenth century when settlers moved into Creek land in Alabama and Georgia, some Creeks fled southward to Florida and joined with Indians of other groups to become the people known as the Seminole. Most of the Creeks who did not go to Florida were removed to "Indian Territory," regions west of the Mississippi River that were not yet settled.

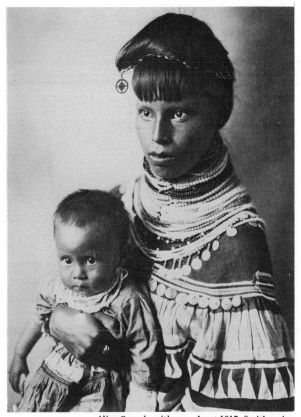

Alice Osceola with son, about 1917, Smithsonian Institution, National Anthropological Archives

Florida was still ruled by Spain, but people from the United States had settled there. In 1818 General Andrew Jackson invaded the territory and soon afterward it became part of the United States. Jackson tried to force all the Seminole to move to the West, and long, bloody wars were fought. Those Seminole who remained in Florida retreated into the swampland.

The Seminole people like to dress colorfully. The men at left are wearing turbans on their heads, decorated with plumes of feathers. One has crescent-shaped gorgets of silver hanging around his neck. These were a badge of rank among Europeans. A woven sash with diamond patterns is stretched across his chest.

The Seminole woman above wears a cape with a patchwork design. Dozens of strands of glass beads with dangling coins are hung around her neck, and a silver ornament decorates her hair. Buttons were sewn onto her cape for extra decoration.

Tommy Jumper and Billie Stewart, about 1890, Smithsonian Institution, National Anthropological Archives

41

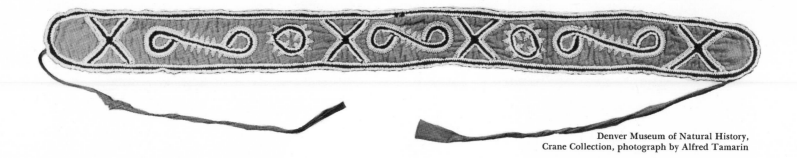

Denver Museum of Natural History,
Crane Collection, photograph by Alfred Tamarin

The sash with beads sewn onto a cloth background, above, belonged to a Choctaw medicine man in the nineteenth century. Before the Europeans arrived in America, men wore belts tied around their waists. Small skin pouches were suspended from them. When the Indians saw the style of European soldiers in the Colonial period, they admired the sashes worn across the chest and over the shoulder and began to wear their own belts in this style. Bullet pouches copied from military uniforms were hung from the belts. The pouches were used to carry tobacco, a pipe, ammunition, and flint and steel to start a fire.

The belt and pouch with a triangular flap at right are decorated with glass beads sewn onto a cloth background. Yarn fringes hang from both the bag and belt. They belonged to Billy Bow Legs, a Seminole chief during the period when the American government was trying to force the Seminole to move West.

Today the Seminole inhabit the Everglades and Big Cypress Swamp of Florida. Some live in modern houses. Others still live in family groups around a cooking shelter, in chickees, huts with thatched roofs of palmetto and open sides. Chickees are raised from the ground on poles.

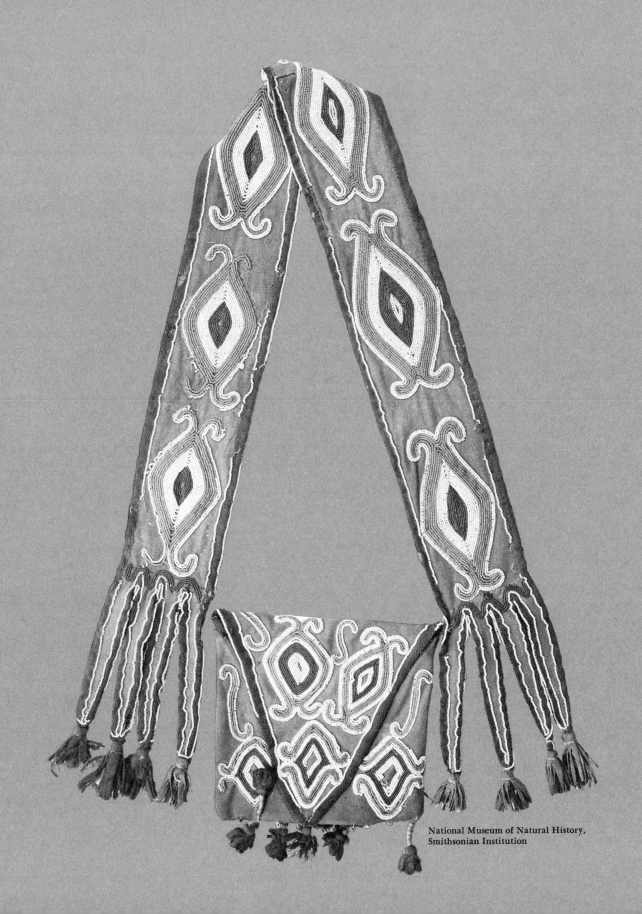

National Museum of Natural History,
Smithsonian Institution

43

The Creek in this picture is wearing a beaded bag over his shoulder. His clothing is in European fashion. His cloth headdress suggests the earlier Indian custom of wearing an animal skin over the head and shoulders. His face is painted with a traditional Indian design. Creek hunters painted designs around their eyes in the belief it would improve their vision.

The Creeks are considered one of the "Five Civilized Tribes," along with the Cherokee, Choctaw, Chickasaw and Seminole. These tribes had their own governments and school systems, and white settlers thought they were more advanced, by European standards, than some of the western Indians.

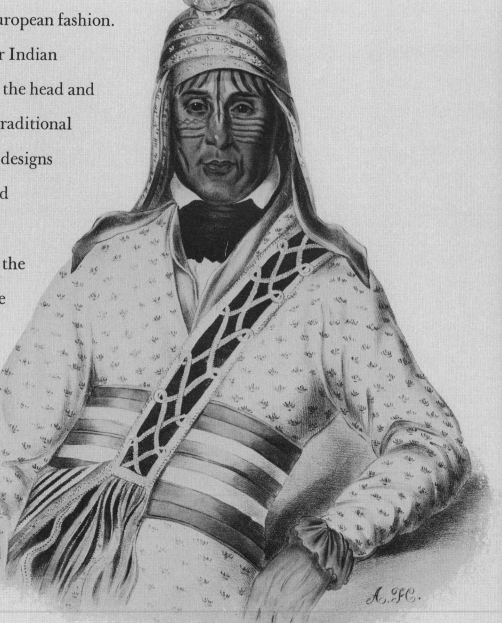

Yoholo Micco,
from *History of the Indian Tribes of North America*
by Thomas L. McKenney and James Hall (1838),
Library of the Museum of the American Indian,
photograph by Alfred Tamarin

This Seminole doll is wearing a neckerchief held in place with a beaded ring, and a turban on his head. Seminole turbans were made of long strips of cloth wrapped around a framework of stiff fiber.

When the sewing machine was invented, Seminole women were among the first to use it. They created a new art form by cutting out strips and small pieces of cotton cloth and sewing them onto a background of cloth in patchwork patterns.

The long shirt on this doll has a patchwork design with stripes and diamond shapes. For the Seminole, the diamond design represents a rattlesnake. Some Southeastern Indians believe the rattlesnake was once a man who was transformed into a snake to save mankind from a disease sent down by the sun.

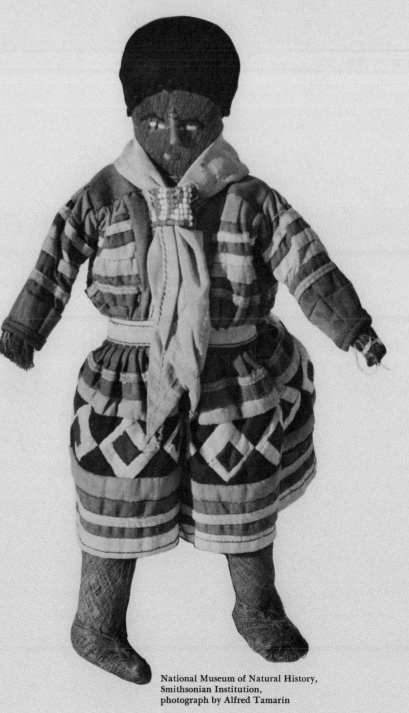

National Museum of Natural History, Smithsonian Institution, photograph by Alfred Tamarin

45

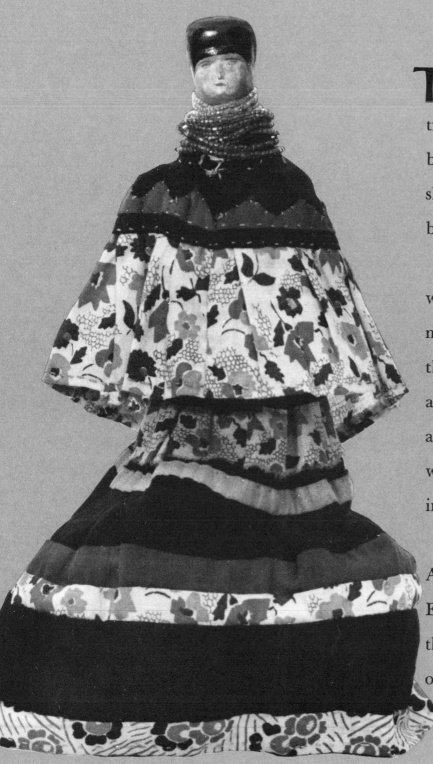

The female doll at left is dressed in a traditional Seminole fashion that is still worn by some women today. She is wearing a long skirt with an overblouse and several rows of beads wound around her neck.

When the Europeans arrived, Cherokee women copied their long gowns, which they made from cloth often spun from cotton that they raised themselves. The Cherokee rag doll at right has a stuffed cloth head, with a nose and mouth stitched with thread. Cherokee women carried their babies on their backs tied into their shawls.

The Cherokee, who lived in the southern Appalachian Mountains, were quick to adopt European customs as well as styles. One of their leaders, Sequoia, developed an alphabet of eighty-five symbols that represented all of

the Cherokee spoken language. When the people of the tribe had learned to read and write their own language, they began to publish a newspaper. It was the first newspaper to be written in an Indian tongue.

The Cherokee were driven out of their land by American settlers in the nineteenth century. They were forced to move to Indian Territory in the West. Many people died on the long, hard journey, which became known as the Trail of Tears. Some of the Cherokee refused to go and hid out in the hills.

Today around five thousand members of the Eastern Band of Cherokee live in North Carolina, high in the Great Smoky Mountains. The Cherokee language is still spoken by many adult members of the tribe and it continues to be taught to the children.

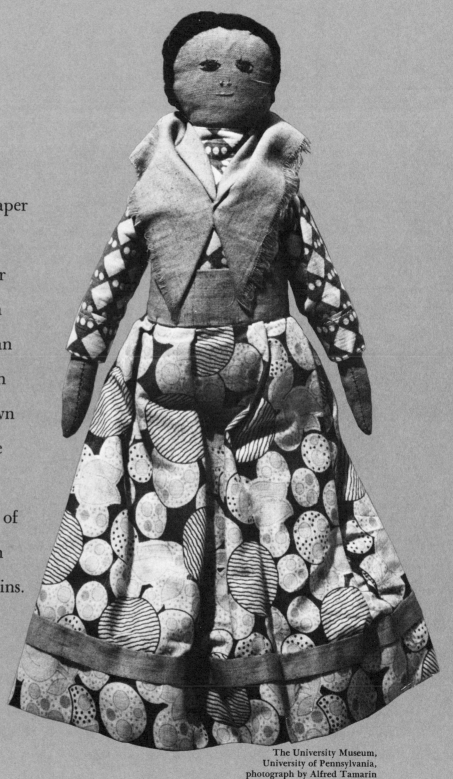

The University Museum,
University of Pennsylvania,
photograph by Alfred Tamarin

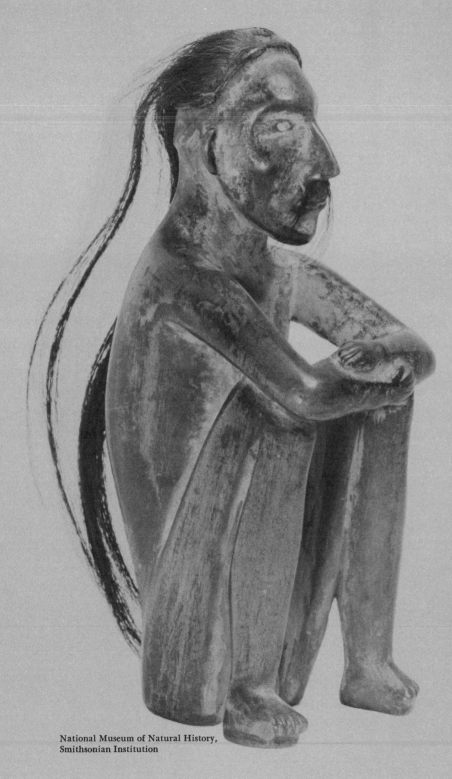

Southeastern Indians have been skilled wood carvers for centuries, and they still work with wood today. This squatting figure was made by a Caddo in Mississippi. He has a wig and mustache of human hair and once held a medicine bundle, a bag containing sacred objects, between his legs.

The Southeastern Indians had a rich and flourishing culture when the first Europeans arrived on the Atlantic shores. As more and more settlers moved into the land, that culture was disrupted and the Indians were pushed out of their homes or were killed. Only a few still live in the area once occupied by their ancestors. Those who stayed and those who moved to the West have adopted many of the ways of American society. Yet they still perform their old ceremonial dances and practice some of the arts of their ancestors. They remain Indian; ancient traditions have not been forgotten.